Start to
Batik

Rosi Robinson

SEARCH PRESS

First published in Great Britain 2009
Search Press Ltd.
Wellwood
North Farm Road
Tunbridge Wells
Kent TN2 3DR

Photographs by Debbie Patterson at Search Press
studios, except for pages 1, 5–9, 21–23, 30–31, 38–39,
and 45–48, by Roddy Paine Studios, and the batik
worker on page 4, by Brigitte Willach.

ISBN: 978-1-84448-353-2

The Publishers and authors can accept no responsibility
for any consequences arising from the information,
advice or instructions given in this publication.

Suppliers
If you have difficulty obtaining any of the materials
and equipment mentioned in this book, please visit the
Search Press website for details of suppliers:
www.searchpress.com

Some words are underlined like this. They are
explained in the glossary on page 48.

Printed in Malaysia

*Dedicated to all the budding artists I
have taught over the years at Cumnor
House School in Sussex, who have been
captivated by the magic of batik.*

Acknowledgements

Thank you to Edd Ralph, my editor; to Debbie Patterson my

photographer; and to Juan Hayward and Marrianne Mercer,

my designers.

The publishers would like to thank consultant
Rebecca Vickers and also the following for
appearing in the photographs:
Rebekah Mate-Kole Rampe, Catherine Stevens,
Jade Searles, Chloe Barnard, Charlie de la Bédoyère,
Georgia Brooks, Emily Murayama, Lottie Brooks,
Yuna Murayama, Imogen Rimmer, Amanda Abrahim
and Henrietta Amos.

Contents

Introduction 4

Materials 6

Techniques 10

Pink and Orange Scarf 16

Aboriginal Art 24

Sunflower Bag 32

Dotty Book Cover 40

More books to read 48

Useful websites 48

Glossary 48

Index 48

Introduction

Batik is an amazing traditional technique in which fabrics are decorated by using wax and dyes. It has a magic about it which I hope you will enjoy exploring. There are so many things you can create or decorate by using wax to <u>resist</u> dyes. This book will show you everything you need to start batik, including batik on fabric and paper.

People have been creating colourful patterns and designs using wax and dyes for over 2,000 years. Traditionally, batik was used to decorate fabric worn as garments, like sarongs. In fact in Java, Indonesia, where some of the finest batik can be found, batik cloth is a national costume.

Nowadays, the technique of batik is used not only for clothing, but for decorating other things. You can batik paper, cards, decorate bags, lampshades, scatter pillows, t-shirts and scarves – you can even create batik paintings. Batik can be both an art and craft and both the designs and the technique continue to influence fashion and design today.

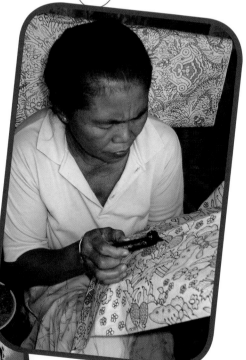

A Sri Lankan batik artist doing some <u>tulis</u> work.

Leopard batik from Sri Lanka. You can find some of the most beautiful figurative batiks in Sri Lanka.

If you can remember that wax and coloured water (i.e. dyes) do not mix (i.e. they resist each other), then you are one step on the way to understanding how batik works. Where an area is waxed, it resists the dyes. The colour under the waxed area is protected while the unwaxed areas take up the dye.

As you work through the projects you will become more proficient in handling the waxes, tools and dyes. Soon you will become more confident and experimental with your designs and pictures. Batik has a magic about it and is so versatile.

Have a go! I am sure you will become as hooked as I am.

FUNKY FACT!

The word 'batik' is thought to come from the Javanese word 'ambatik', derived from 'tik', which means to mark with drops or spots. Batik is most commonly associated with the Indonesian island of Java.

Materials

Wax

For the projects in this book, I use ready-mixed batik wax which is a very versatile, ready-blended combination of hard (paraffin) and soft (beeswax) wax. It is sold in blocks, pellets or flakes in hardware stores and craft shops. You can also make up your own blend of paraffin wax and beeswax.

Paraffin wax cracks more readily and beeswax is more pliable. A combination of three parts paraffin wax to one part beeswax is a good basic wax medium. If more 'cracking' is required, use more paraffin wax, and if a smooth surface is required, use more beeswax.

Wax pot

Wax has to be heated to the correct temperature before it can be applied to the fabric surfaces. It is important to maintain a constant temperature, so the most practical and safest way to heat the wax is in a thermostatically-controlled wax pot. These can be bought from specialist suppliers.

An old electric frying pan, which has a built-in temperature control, is an ideal wax pot for stamping with cookie cutters etc as it is flatter and larger than a wax pot. The temperature should not exceed 48°C (120°F) and it must not be allowed to smoke.

The wax should penetrate the fabric and should appear transparent. If it appears opaque it is too cold.

TOP TIP!

Microcrystalline wax is a cheaper alternative to beeswax.

STAY SAFE

- Wax is flammable, so never heat wax directly over an open flame or an electric burner.
- Never leave the room without turning off the heat source.
- In the unlikely event of a fire, snuff out the flames with a cover or lid – never use water.

STAY SAFE

Wax pots get hot! Never touch the metal while you are working. If the wax begins to smoke, turn down the temperature.

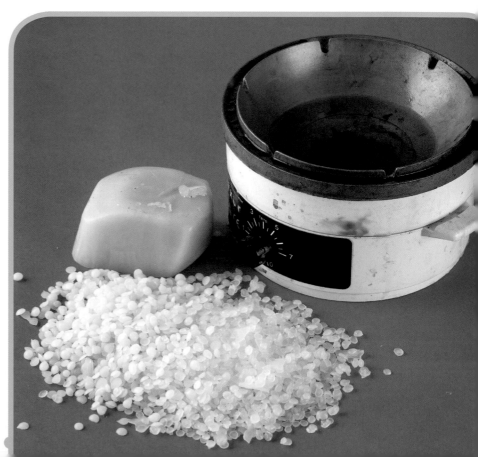

A wax pot next to a block of beeswax, ready-mixed batik wax pellets (yellow) and paraffin wax pellets (white).

Tools for applying wax

Brushes Choose good-quality, stiff, natural bristle brushes – not soft-haired or synthetic ones. Flat or wide brushes are good for filling in large areas quickly and for spattering. Fine, round Oriental brushes with a point hold a lot of wax and are good for dots, lines and for filling in.

It is difficult to remove wax from brushes (unless you clean them with white spirit), so they are best kept just for waxing. You will find that the bristles become stiff when the wax solidifies, but they soften up again when dipped in hot wax.

Cantings Cantings (pronounced tjantings) are the traditional Javanese tools for drawing fine lines and dots of wax. Usually they have a wooden handle attached to a brass or copper bowl with a spout or spouts. The hot wax flows through the spout, and the size of the spout controls the width of the line (of the design). Some cantings have double and triple spouts. You have better control if your spout is not too large. Indonesian and Western designs of cantings are available from craft suppliers.

Kystkas Similar to cantings are tools called kystkas, which are used by Ukrainians for decorating eggs. These are also excellent for drawing fine lines and dots, and come in three sizes of spouts. For the projects in this book I have used an Indonesian style canting and a kystka. You can obtain these, and other cantings, from craft shops or craft suppliers.

Stamps and **Caps** Stamps or caps (pronounced tjaps) can be used for applying wax on to fabric, rather like a printing block. While traditional Indonesian caps have very intricate patterns, you can create very effective designs by stamping with common household goods such as cookie cutters, potato mashers, cardboard tubes, corks from wine bottles and paper towels. Experiment with different things!

Cantings, kystkas and brushes.

TOP TIP!
Never leave brushes in the wax pot as they will lose their shape and may also lose their bristles.

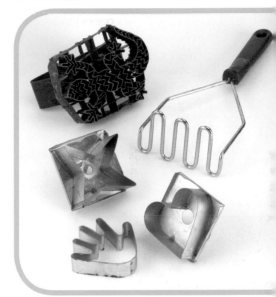

A traditional cap (top left) alongside a potato masher and cookie cutters – almost anything can be a stamp!

Dyes and dye tools

Dye I use Procion MX cold water <u>fibre-reactive dyes</u>, as they can be used with a wide range of fabrics and papers. They are also very versatile and can be used for immersion dyeing (i.e. dip-dyeing), hand painting and spraying.

You do not need to buy lots of colours. Choose three primary colours – two of each: lemon yellow and golden yellow; scarlet red and magenta or fuschia; turquoise and royal blue; and a dark colour like black or navy blue. You can make all the colours you need from these. Most brands of dye come as powders, which will keep almost indefinitely in an airtight container in a cool dry place. Cold water direct dyes can be used, but they are less versatile.

You can vary the ratio of dye colour to 250ml (½pt or 9 US fl.oz) water to produce a range of shades: half to one level teaspoon of dye for a pale shade; two to three level teaspoons of dye for a medium shade; and five or more teaspoons of dye for a dark shade.

Dye brushes You can use a variety of brushes for applying dyes. I like to use oriental watercolour brushes as they hold a lot of dye and have a good point, but normal watercolour brushes work equally well. Sponge brushes of different widths are ideal for laying washes over large areas of fabric.

Spray bottles You can also apply dye through pump spray bottles (available from craft shops) or plant misters.

Mixing pots You will need a few jars or plastic pots for mixing and storing dyes and chemicals. You will also need a jar of clean water for rinsing brushes. Syringes or droppers are ideal for transferring dyes from the jars to the palette. Deep-welled palettes or small glass dishes are perfect for mixing dyes in.

Paper and fabric

Fabrics should be smoothly woven, medium-weight, white or light-coloured (the background colour will affect subsequent dyeing) and made from 100 per cent natural fibres – cotton, silk, linen, velvet and wool. The dyes I use react only with natural fibres – the denser the weave the more intense the colours are. In addition, note that the wax will not penetrate the fibres if the fabric is wet, and so will not act as a resist to the dyes. Always make sure the fabric is dry when applying wax to your work.

Viscose also gives good results, but polycotton and synthetic materials do not take up the dye very well, and only washed-out colours will result. Calico, poplin, cotton lawn, rayon, viscose, habotai silk, organdie, chiffon, crepe de chine and voile are all suitable for batik. You should apply the wax to both sides of thick fabrics (such as canvas or velvet), to ensure good penetration.

Any light- or medium-weight, thin porous paper can be used for batik. Tissue paper or oriental watercolour paper is perfect. You can even re-use printed tissue paper that is used by shops to wrap up goods.

Ready-made objects like scarves, bags, hats, t-shirts and scatter pillow covers can all be used, but you must ensure you have washed them beforehand in a mild detergent to remove any dressing or finish, to make them more absorbent and prepared for dyeing.

Other materials

Frame For most projects, it is best to stretch the fabric on a frame to keep it raised above the work surface. Specialist batik frames can be bought from craft shops, but artists' stretchers, old picture frames, or embroidery frames are also ideal for batik.

Cover the working side of the frame surface with parcel tape. This can be wiped clean to prevent dye staining later projects.

Pins and **thumb tacks** You will need some pins to stretch the fabric to the frame. Three-pronged silk pins are ideal, but ordinary thumb tacks work just as well.

Soda ash This is sodium carbonate, an alkali fixing agent used to bond the dyes to the fibres of the fabric. It is available from selected craft shops and dye suppliers or as washing soda crystals.

Fix solution This is needed for dip-dyeing. It makes sure the dye stays in the fabric. To make it, dissolve two heaped tablespoons of soda ash (see above) per litre (2pt) of water. This can be stored separately, at room temperature, in a bottle for a number of weeks. Do not mix it with the dye until just before you are ready to dye your fabric.

Salt This helps to produce an even colour when it is added to a dyebath when dip-dyeing.

Dyebath or **bucket** Used for dip-dyeing, these should be large enough to allow the fabric to be completely immersed. Large shallow containers often work better than tall narrow ones. Plastic, glass stainless steel or enamel containers are all suitable, but do not use copper, aluminium, iron or galvanised containers.

Hairdryer Occasionally, I use a hairdryer to dry dyes.

Iron and **ironing board** Use a non-steam iron to remove wax from a finished batik. Use an old ironing board or cover the ironing board with a wad of newspaper, to protect the surface.

Plastic sheet Used to protect your work surface.

Paper towels These are great for mopping up spills and catching drips of wax from cantings and kystkas.

Spray glue Ideal for mounting finished paper batiks on to board. You can purchase special **acid-free self-adhesive mounting board** for mounting fabric batiks.

Dust mask Most dyes have very fine powders, so wear a filter-type face mask when mixing them.

Scissors These are used for cutting paper or sponges.

Rubber gloves and **apron** To protect your hands and clothing, wear these items when dyeing.

Measuring equipment You will need a measuring jug, pipettes and a selection of spoons for making up the dyes and chemicals.

Scrap paper Used to protect your work surface. **Newsprint** is also used for ironing out the wax from the finished batik.

Fine fuse wire This is used to clean or unblock spouts on cantings.

Extension lead Use one of these if your wax pot is not near to a power socket.

Pencil Use a soft pencil to draw designs on white or pale fabrics.

Masking tape This is useful for masking for spattering.

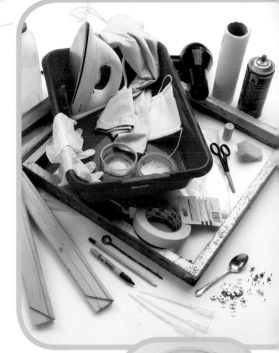

Black pen This is used to outline the designs on to paper before they are transferred on to fabric.

Sponge Used to apply wax.

soda ash

Cork This is used as a stamp.

Plastic milk carton This is filled with fix solution.

Teaspoon Used to measure and stir dyes.

Skewer This is used for a technique called *sgrafitto*, which is etching into wax.

Techniques

In this section, I show you how to prepare the fabric, wax and dyes. I have used one piece of cotton fabric to show you different ways of applying the wax – with brushes, cantings, kystkas and stamps – and also how to spatter wax. Then I will show you how to paint on the dye, so if you work through the techniques, you will make a lovely piece of art!

Preparing the fabric

Before you begin, the fabric must be prepared by soaking it in a fix solution of soda ash and water. This helps the dye to stay in the cotton (i.e. to become fixed) and keeps the colours bright. Ensure you wear gloves to protect your hands, and make sure that the water is not too hot.

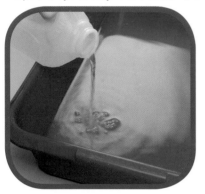

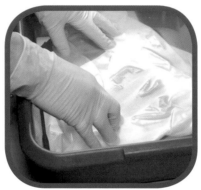

1 Add two tablespoons of soda ash to one litre (2pt or 32 US fl.oz) of warm water and stir with your gloved hand or a wooden spoon, until dissolved. Pour the mixture into a plastic bowl.

2 Immerse and soak the fabric in the solution for ten minutes or longer, then take it out and squeeze out the water. Hang it up to dry naturally. (Do not use a clothes dryer).

3 Iron the fabric at a medium heat and then use thumb tacks to secure the cotton on to a wooden frame. Make sure the fabric is taut.

Preparing the wax

Wax must be melted before you apply it. A thermostatically-controlled wax pot is a safe way of heating the wax. It also ensures that the wax stays at a constant temperature.

TOP TIP!

Before you start, stretch fuse wire across the top of your pot. This can be used to scrape off the excess wax.

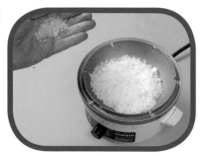

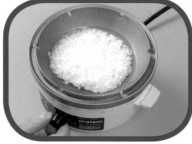

1 Add wax to the pot until it is roughly three-quarters full.

2 Set the temperature to a medium heat, and watch as the wax starts to melt.

3 Wait until all the wax has melted. The pot will keep it molten as you work. If you have unmelted wax in the pot, the temperature is not quite high enough, so turn it up a little.

Drawing with wax using a brush

Use a brush when you want to draw lines, dots or cover or protect large areas with wax. The brush does not hold the heat for long, so you may have to immerse it in the wax more frequently than you expect, to ensure that your brush stroke has penetrated the fabric.

Notice that the waxed areas look darker than the unwaxed areas, and this can be confusing. However, if you hold the the batiked fabric up to the light, you will see the true underlying colours. You can also judge if you have missed any area by looking on the reverse side of the fabric. If the wax is opaque, then the wax is not hot enough and will not act properly as a resist, so you will need to apply wax to the reverse side if there are any gaps in the line.

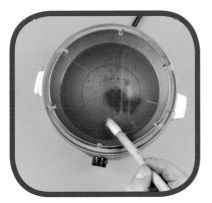 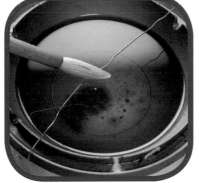

1 Dip the brush in the molten wax and allow to soften. Try not to let the bristles touch the bottom of the heated pot.

2 Scrape the excess wax off on the wire. If you do not have any wire, simply scrape the wax off on the lip of the wax pot.

3 Apply the wax and repeat until you have the pattern completed. The waxed areas will remain the white colour of the fabric. The fabric will appear transparent where the wax has penetrated.

Applying wax with an object

Repeated patterns can be applied by stamping objects such as cookie cutters, cardboard tubes, nuts and bolts with the wax. Metal objects are the best as they retain the heat, but almost anything can be used to create a design or texture on the fabric.

In this example, I have turned the fabric upside down so I can rest it on a hard surface. Because this means I am stamping on the back, the image will be reversed. This does not matter here because the stamp is symmetrical.

> **TOP TIP!**
>
> It is better to unpin the fabric and place it on a hard surface before you stamp.

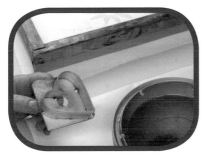 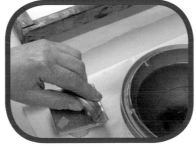

1 Turn the frame upside down, and dip the object in wax. Keep the stamp in the wax long enough for it to get hot, otherwise the wax will not penetrate the fabric when you stamp with it.

2 Stamp the object on scrap paper to remove the excess wax.

3 Immediately stamp the object on the fabric, then repeat the process. Once you have finished stamping, turn the frame the right way up again.

Masking and spattering

If you want a fine spattered effect, try tapping your wax-filled brush against a dowel or brush handle. Protect areas you do not want spattered with a stencil or scrap paper – or, as in this example, with masking tape.

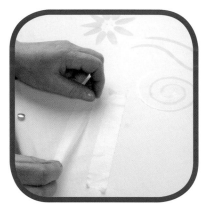

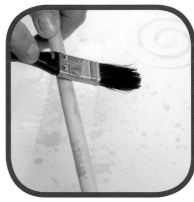

1 Place the frame on scrap paper to protect your work surface and surrounding area, and apply masking tape in strips as shown.

2 Hold a wooden dowel a short distance above the fabric. Dip a large brush in the wax, and tap it firmly across the dowel to flick droplets of wax on to the fabric. Remember to keep the head of the brush slanting down, to prevent the wax from spattering over your work surface.

3 Peel off the masking tape to reveal the full effect.

Applying wax with a canting or kystka

Use a canting when you want to draw lines, dots, outlines or doodles. Kystkas are also great for thin lines. You will be surprised how much wax these little tools can hold. When you feel the wax is cooling, dip the canting into the hot wax again and 'refuel' it.

If the flow of the wax is impeded, either the wax is not hot enough or the canting is blocked. Dip the canting into the wax to melt the wax in it and then push a piece of fuse wire down the spout to unblock it.

FUNKY FACT!

Wax drawing with a canting is called *tulis* work in Indonesia. *Tulis* is a Javanese word meaning hand-drawn wax resist. Traditionally, Javanese women do the *tulis* work while the men do the stamping or cap work.

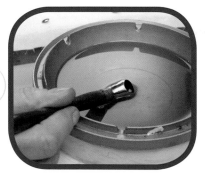

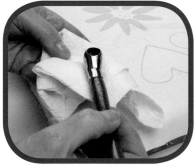

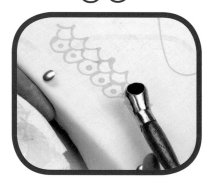

1 Dip the canting in the wax. Take care not to overfill it. Hold it in the wax long enough for the copper or brass bowl to be heated thoroughly.

2 Holding a paper towel beneath it to catch any drips, wipe the bottom of the bowl and take the canting over to the fabric.

3 Hold the canting at a 45 degree angle and draw with it. Often the flow of the wax will dictate the speed you draw. Go with the flow!

Applying dye wet-on-dry with a brush

Once you have finished the first stage of waxing, then you have to mix up some dyes to colour the fabric. In most of the projects in this book you will apply the dye directly; i.e hand-paint the dye on to the fabric.

If you want to colour a small area, you can paint on the dye, wet-on-dry. The dye will spread a little and will form a rippled hard edge which can be used as part of your design, such as the centre of a flower.

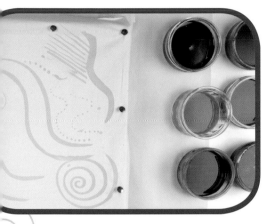

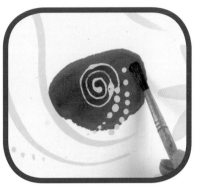

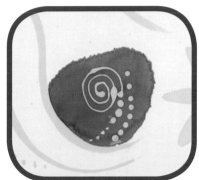

1 Prepare the dyes following the instructions on the packet or dye container and protect your surface with plastic and scrap paper (newsprint or newspaper).

2 Use a clean brush to paint the fabric with dye, over the wax.

3 Allow the dye to dry. You will notice that where the dye spreads, it leaves a hard, ragged edge.

Applying dye wet-on-wet

The best way to blend colours on fabric is to apply the dye wet-on-wet. The colours will spread more quickly and will merge into each other without leaving a hard line or brush mark. By using a sponge brush with a little clear water, you can blend the colour and graduate it from dark to light.

TOP TIP!

To avoid murky colours, start with the primary colours – and you will create beautiful secondary colours: orange, purple and green.

1 Dampen the fabric with clean water, using a wet sponge brush.

2 Use the sponge brush to apply the first dye colour. Note how the waxed areas resist the dye.

3 While the first dye is wet, apply the second dye colour.

4 As you continue, use different colours and note how they blend and mix together. Allow to dry once you have finished.

Adding layers

In order to make the pattern more detailed, keep some of the colours by doodling and drawing with the waxing tools as before. This time the area where you wax will remain the colour underneath and the unwaxed areas will become secondary colours. You can build up layers of wax and colour until you have reached the darkest, final dye.

1 Make sure that the previous layer is dry, then apply wax as before. Use different objects, stamps and so on. The wax will dry immediately on application.

2 Once you have finished your waxing, then apply a dark dye to the fabric. Allow it to dry completely.

NOTE

Dye colours always appear darker when wet, so test colour mixtures on scraps of the same fabric as your project and allow it to dry beforehand to see if it has the intensity of colour you want.

Removing the wax

Once all the dye has dried, you need to remove the wax from the fabric. This is easily done using newsprint and an iron. Ideally, you should use a non-steam iron – certainly not your best iron! – to remove the wax from the finished batik. Similarly, use an old ironing board or cover the ironing board with a wad of newspapers before you begin to protect the surface.

1 Once all of the dye is dry, unpin the fabric and sandwich the piece between two pieces of newsprint and iron it with a warm iron.

2 Peel off the paper and repeat with new pieces of newsprint, both above and below, until no more wax appears.

TOP TIP!

You can iron your batik between old newspapers, but test it beforehand in case some of the print leaves marks on your fabric.

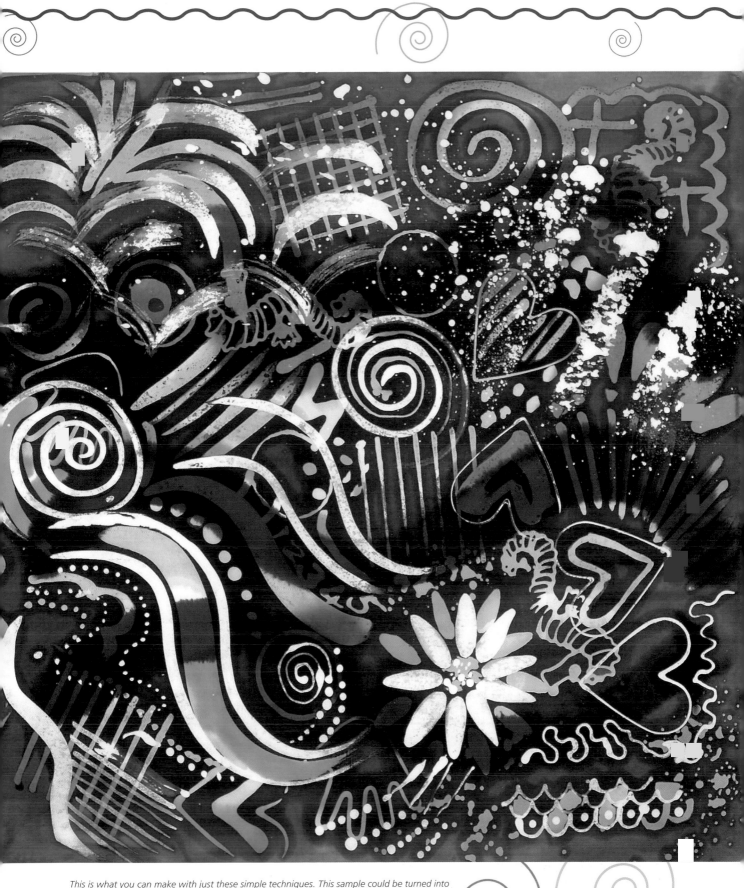

This is what you can make with just these simple techniques. This sample could be turned into one side of a scatter pillow cover.

Pink and Orange Scarf

You will need

A ready-made white viscose or silk scarf

Wax and wax pot

2cm (¾in) flat bristle brush

5cm (2in) flat bristle brush

Star-shaped cookie cutter

Magenta and orange cold water fibre-reactive dye

Sponge brush

Sponge and scissors

Rubber gloves

Plastic bucket

Thick plastic sheet

Salt and soda ash

Glass bowl and teaspoon

Newsprint

Apron

NOTE

This scarf has a subtle striped design that I am using to help me decide where to decorate. You should feel free to use the design on your scarf to help you!

In this project you will learn how to decorate a scarf. You can often buy inexpensive scarves ready-made. Here is your chance to decorate it with your own design. You will learn how to apply the wax with different brushes and ready-made stamps. You will also learn how to dip dye as well as hand paint.

1 Use sharp scissors to cut a piece of sponge into a sharp point, then prepare your wax (see page 10).

STAY SAFE

Always have an adult with you when working with hot wax.

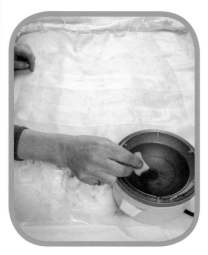

2 Protect your surface with the large, thick, plastic sheet and lay your scarf out flat on it. Dip the point of the sponge into the prepared wax.

3 Draw a zigzag pattern down the scarf, approximately 10cm (4in) in from the edge.

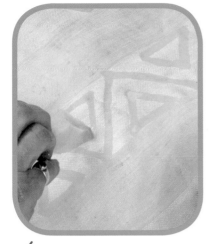

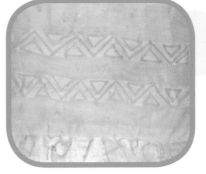

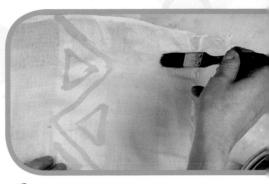

5 Leave a gap of 10cm (4in) and repeat the pattern of zigzags and triangles.

6 Use the flat of the 2cm (¾in) brush to draw a line of wax off the edge of the scarf in the top corner as shown.

4 Draw triangles in the spaces of the zigzag.

NOTE
Because this scarf is made of a loose-weave material, lift it up every so often to make sure that the wax is not sticking it too firmly to the plastic.

7 Use the thin side of the 2cm (¾in) brush to draw a line of wax underneath the thick line.

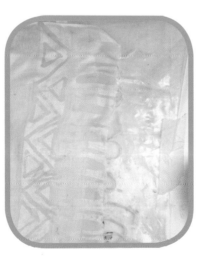

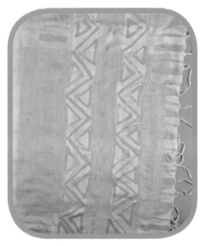

8 Repeat drawing thick then thin lines down the whole border.

9 Repeat this to the left of the left-hand zigzag, and paint a row of wax dots in between the zigzags. This completes one end of the scarf.

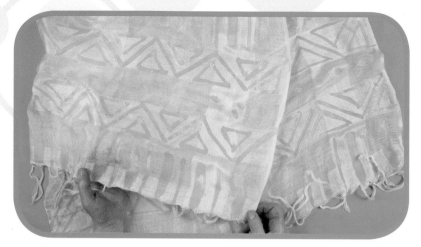

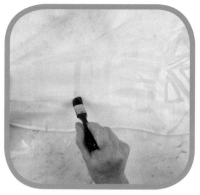

10 Turn the scarf over and repeat on the other end.

11 Use the 2cm (¾in) brush to draw a group of three lines along the border as shown, 10cm (4in) from the bottom, at right angles to the lines you made in step 8.

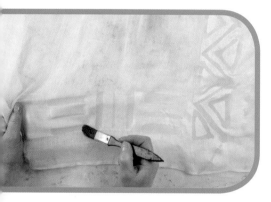

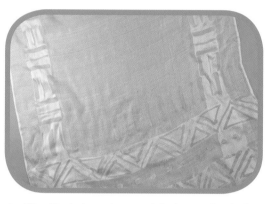

12 Draw a second group of three lines at right angles to the first.

13 Work along the rest of the bottom border in the same way, then repeat the patten along the top border as shown.

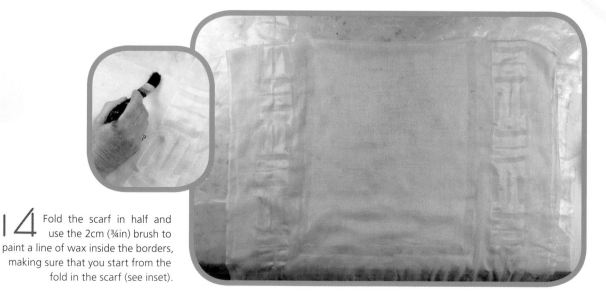

14 Fold the scarf in half and use the 2cm (¾in) brush to paint a line of wax inside the borders, making sure that you start from the fold in the scarf (see inset).

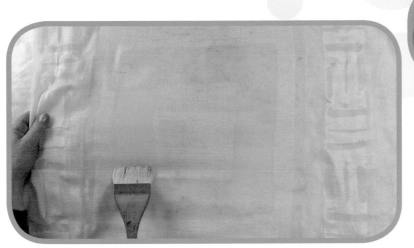

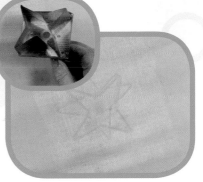

16 Stamp a star of wax in the centre of the square using the cookie cutter (see inset), and add a dot in the middle with the 2cm (¾in) brush.

15 Use the 5cm (2in) brush to paint a large square of wax on the scarf, inside the border line you made.

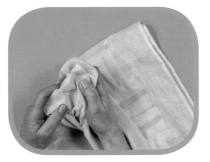

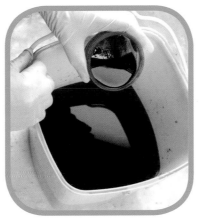

17 Lift the scarf off the plastic and screw up the square and star in your hands. This cracks the wax, giving a marbled or crackled effect when the scarf is dyed.

18 Put on your rubber gloves, then put one teaspoon of magenta dye powder into a glass bowl. Make it into a paste with one tablespoon of lukewarm water, adding some more water a little at a time until it is thoroughly mixed. Stir the mixed dye into two litres (4pt or 64 US fl.oz) of lukewarm water in a bucket to make a dyebath. Four tablespoons of salt can be dissolved in the water at this stage to help brighten the colours but it is not compulsory.

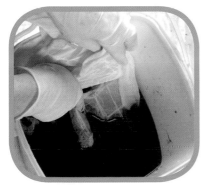

19 Wet the scarf in cold water then immerse it in the dyebath. Gently move the scarf around continuously for 10–15 minutes to ensure an even penetration of the dye.

NOTE

See page 9 for more information on fix solutions, dyebaths and dip-dyeing.

20 Remove the scarf from the dyebath. Place four heaped teaspoons of soda ash in hot water and stir until it is completely dissolved to make a fix solution. Add the solution to the dyebath. This will help the dye to 'fix' in the cloth. Replace the scarf and leave it in the dyebath for 45 minutes, turning it regularly at intervals.

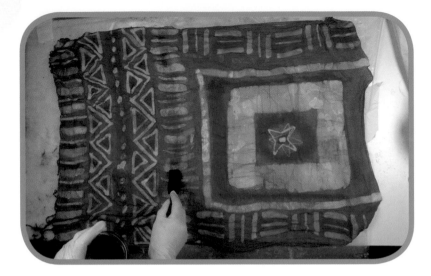

21 Lift the scarf out of the dyebath and gently squeeze out excess dye, taking care not to scrunch up the waxed design. Rinse the scarf under clean water until the water runs clear. Lay it flat and blot the scarf with newsprint or paper towels. Use a sponge brush to apply orange dye (mixed as before, this time including two teaspoons of the soda fix solution) to the patterns on the scarf. Hang the scarf on a line, away from direct sunlight and allow to dry naturally (preferably in a humid atmosphere) for at least 2–3 hours. Rinse to remove surface colour and dry again.

NOTE

If you hang the scarf indoors, place a newspaper or bucket on the floor to catch the drips.

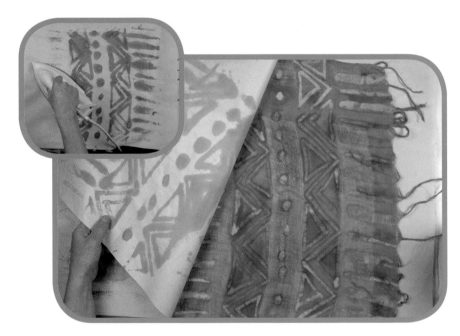

22 Sandwich the scarf between layers of newsprint (or paper towels). Iron it on a medium heat (see inset) to remove the wax.

23 Continue ironing out the wax, working in sections until it has all been removed. You will get most of the wax out by ironing, but if you can get it dry cleaned as well, then you will find the scarf will become soft and bouncy, as dry cleaning the scarf removes any residual wax.

The finished scarf
Batik is a wonderful way to decorate scarves.

What next?

Brightly coloured scarves are fun and can brighten up an outfit! Once you have had a go and feel more confident, why not try batiking silk and chiffon scarves? Always make sure that you use your iron on the correct heat setting when ironing out the wax.

Aboriginal Art

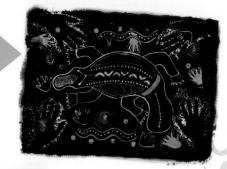

Aboriginal paintings are a wonderful source of inspiration. You will learn how to use the techniques explained earlier to stamp the wax, to create the dot effect of Aboriginal paintings. You will learn how to spatter wax using a paper stencil as well as how to etch lines into the wax (*sgraffitto*). Finally, you will learn how to build up a design using layers of wax and dyes resulting in a beautiful picture.

You will need

Wooden frame, 68.5 x 55.8cm (27 x 22in)

Cotton fabric 68.5 x 55.8cm (27 x 22in)

Wax and wax pot

2B Pencil

Thumb tacks

Kystka and canting

Pointed round brush

Large and medium sponge brushes

2cm (¾in) brush

Hand-shaped cookie cutter, and clothes peg to hold it

Cork and skewer

Golden yellow, red and black fibre-reactive dyes

Spray bottle

Paper towels

Mixing dish and teaspoon

Newsprint

Rubber gloves and apron

Soda ash

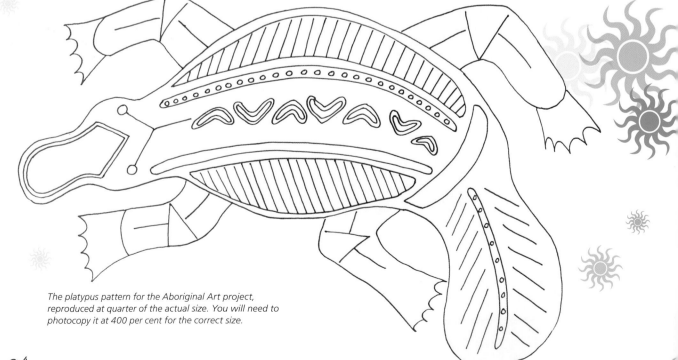

The platypus pattern for the Aboriginal Art project, reproduced at quarter of the actual size. You will need to photocopy it at 400 per cent for the correct size.

Always have an adult with you when working with hot wax.

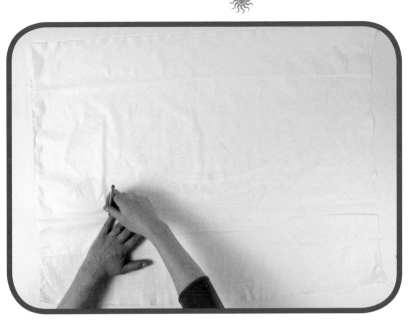

1 Prepare the cotton fabric with the fixing solution (see page 10) then photocopy the platypus pattern and lay the fabric over it. Use the 2B pencil to trace the pattern.

2 Draw round your hand in various places around the platypus.

3 Pin the cotton to the frame using thumb tacks.

4 Using the round brush, draw round the outline of the platypus with wax. Work slowly and carefully, dipping the brush frequently into the hot wax to ensure that the wax line is strong and penetrates the fabric.

5 Still using the brush, fill in the centres of the decorations running down the spine of the platypus.

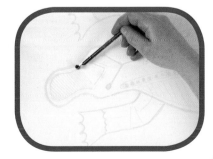

6 Use the wooden end of the brush to fill in the dots on the back and tail of the platypus.

7 Use the canting to draw the eyes and a y-shaped decoration on the head.

8 Use the kystka to outline the inner bill and fill it in with diagonal lines.

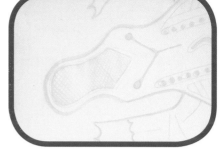

9 Draw diagonals in the opposite direction to make a grid on the bill.

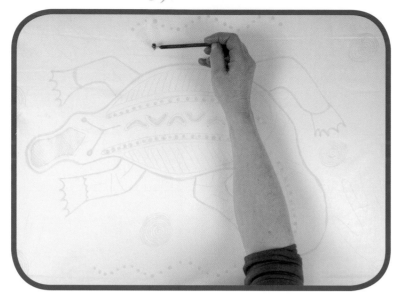

10 Draw dots at the top and the bottom using the back of the brush, and add concentric circles here and there on the background using a kystka.

11 Draw round your hand on scrap paper and cut it out (see inset). This will be used as a stencil. Use scrap paper to cover and protect the platypus, then place the hand stencil over the drawn hands on the cotton. Use the 2cm (¾in) brush and wooden dowel to spatter wax around it.

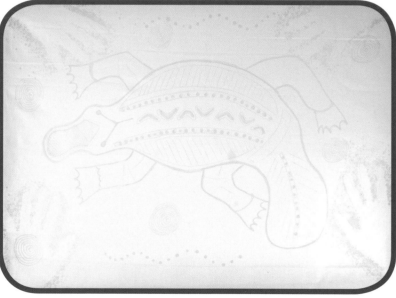

12 Repeat over the rest of the fabric.

13 Protect your surface with the plastic sheet and put on rubber gloves. Place one teaspoon of golden yellow dye powder in a glass dish, then add a drop of lukewarm water and mix it up into a paste (see inset). Add a little more water until you reach the consistency you want: the more water you use, the paler the dye will be.

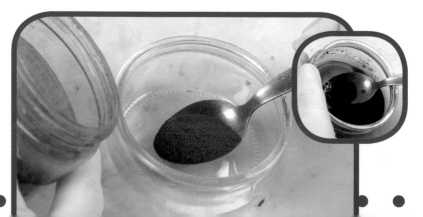

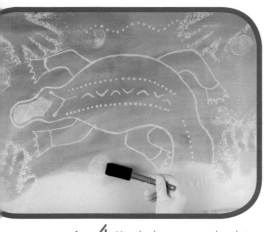

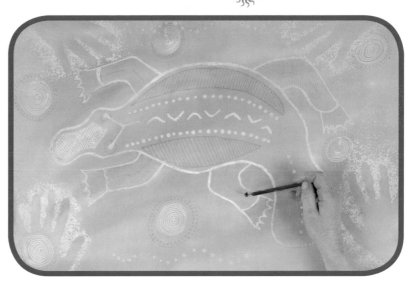

14 Use the large sponge brush to dampen the fabric with clean water, then use the smaller one to lay in the yellow dye. Leave to dry.

15 Once the fabric is dry, use a kystka to outline the decorations on the sides of the platypus, then to add dots around the circles and on the legs of the platypus.

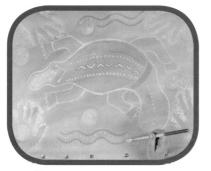

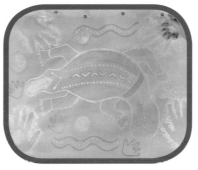

TOP TIP!

If you can not find a hand-shaped cookie cutter, use a canting or brush to outline random hands in wax.

16 Use the pointed round brush to outline the decorations on the spine; draw a broad stroke at the base of the tail, and smaller wavy lines above and below the platypus.

17 Use the peg to hold a small hand-shaped cookie cutter. Dip it in the wax and stamp it over the background, as shown.

18 Use a cork to stamp some dots of wax over the piece and a brush to dot between the dots on the tail.

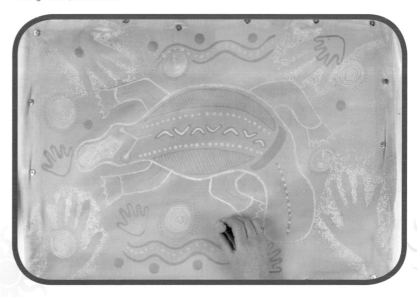

19 Draw round the hand-shaped cookie cutter on to scrap paper and cut it out to make a mask stencil. Protect the platypus with scrap paper and place the mask stencil on the top right. Mix the red and black dyes together to make a red-brown dye (prepared in the same way as the dye on page 19), put it in a spray bottle and spray around the mask.

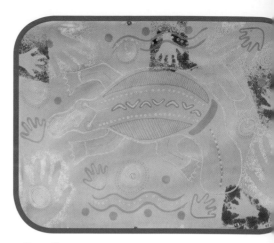

20 Remove the mask stencil to reveal the masked-out hand. Repeat over the whole piece and allow to dry.

21 Dampen the whole piece except for the masked-out hands using the large sponge brush. Use the smaller sponge brush to apply red-brown dye over everything except the masked hands. Allow to dry, then repeat the process to strengthen the red-brown colour.

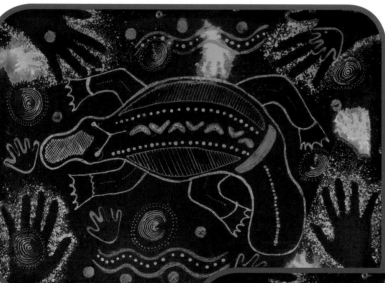

22 Sometimes the dye dries on the surface of the wax, so use a damp sponge or paper towel to clean it to ensure this dye does not stain the fabric when you iron out the wax. Next, use the pointed round wax brush to wax over the background, the insides of the masked-out hands, and part of the platypus, leaving unwaxed areas ready for the final dark dye.

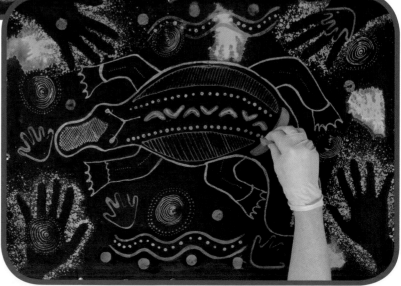

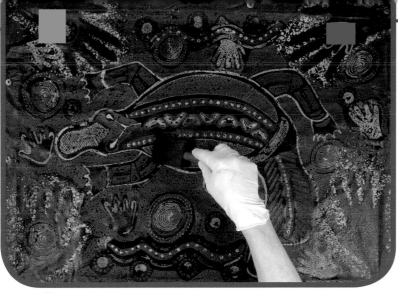

23 Use the skewer to etch a design into the wax at the base of the platypus' tail. This technique is called *sgraffito*.

24 Prepare black dye with fix solution (see page 9) and cover the whole piece using a sponge brush. Allow the piece to dry completely.

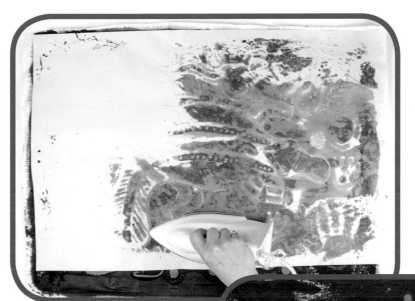

TOP TIP!

Fix solution will be drawn out of your prepared cloth after a few layers of colour as you rinse, so mix your dyes with the fix solution after each rinse to ensure that the dyes are fixed properly.

25 Remove the piece from the frame, sandwich it between sheets of newsprint and iron it at a medium setting until the wax begins to soak into the newsprint.

26 You may need to swap the newsprint if it gets too soaked with wax. Repeat the ironing until as much of the wax is removed as possible. Finally, dry clean the fabric to remove any remnants of wax.

29

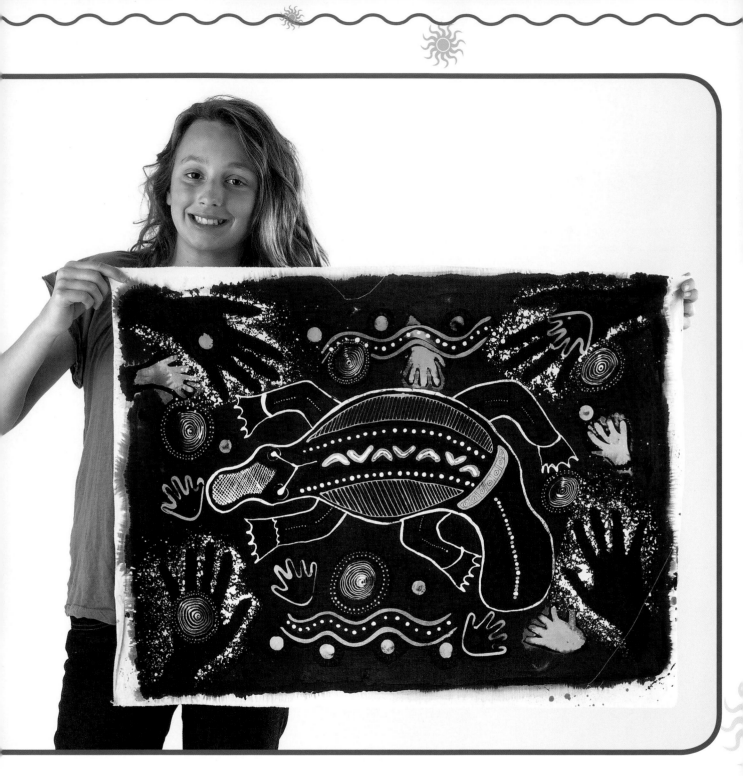

The finished Aboriginal Picture

This design could be framed as a picture. Stick it down on self-adhesive mounting board and frame it with or without glass. You could also turn the batik design into a scatter pillow cover by sewing a backing on to it.

Vary the design and experiment with the tools to create your own Aboriginal batik painting.

What next?

You can use the same techniques with fabric to make other pictures, scatter pillow covers or even picture frames – simply cut a hole in the centre, sew them on to a piece of cardboard and stuff them with padding!

Sunflower Bag

You will need

- A ready-made cotton or canvas bag
- Soft 2B pencil
- Tea saucer or side plate
- Wax and wax pot
- Pointed round brush
- Sponge brushes
- Pen lid or a piece of copper tube
- Lemon yellow, golden yellow, scarlet red, reddish-brown and blue fibre-reactive dyes
- Glass dishes and soda ash
- Teaspoon
- Paper towels
- Rubber gloves and apron
- Thick scrap paper

Bags are always useful and fun to have. In this project, you will decorate a ready-made canvas bag.

As it is thick material, you will have to ensure that the wax is hot enough to penetrate the fabric so it will resist the dye. You will also learn how to apply the wax with a brush and some stamps, and how to build up layers of colour, starting with the lightest and leading to the darkest colour.

You should pre-soak the bag in the soda ash fix solution, but it will need to dry overnight. If you are anxious to start immediately, you can mix each dye with the fix solution (see page 10) just before you need it. Also remember that when you mix the dyes with the fix solution, use the dyes within four hours to ensure the dyes fix properly.

Put a sheet of thick paper in the bag. This will stop the wax and dye spoiling the back while you work on the front.

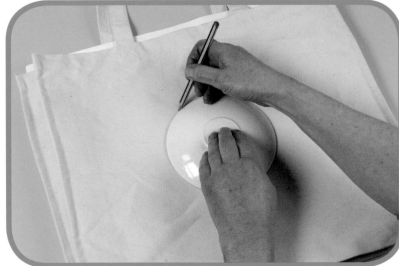

2 Use the pencil to draw round a tea saucer on the front of the bag.

3 Use the 2B pencil to draw some large petals around the circle.

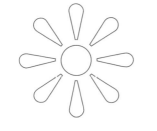

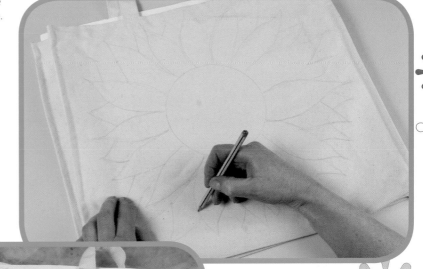

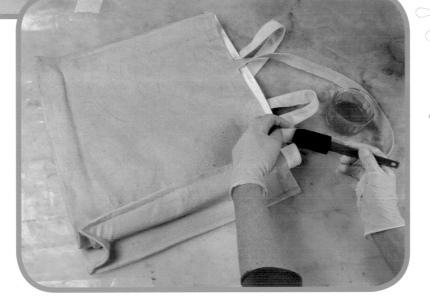

4 Prepare a lemon yellow dye and use a small sponge brush to cover the whole front of the bag with it. Work it into the fabric of the bag.

5 Dye the bottom, side panels and the front handle in the same way. Allow it to dry, then rinse it in clean water to remove excess dye and allow it to dry again.

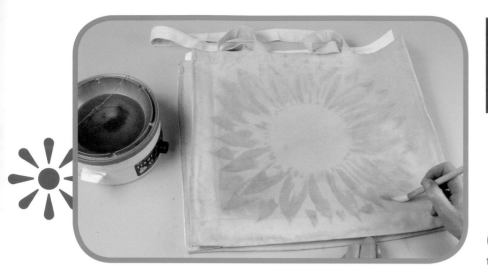

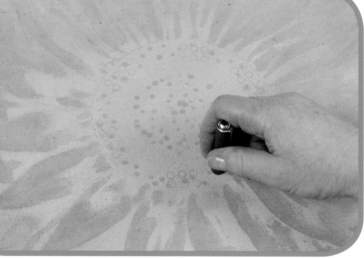

STAY SAFE

Always have an adult with you when working with hot wax.

6 Use the round brush to work wax into the tips and edges of the petals.

7 Use the back of the brush to dot wax into the centre of the flower (see inset), then dip the pen lid or copper tube into the wax and use it to stamp small hoops.

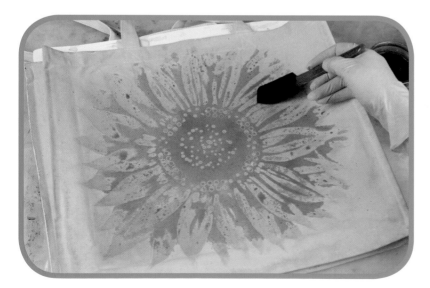

8 Prepare a golden yellow dye and use the small sponge brush to cover the flower. Allow the dye to dry, rinse the bag in clean water to get rid of excess dye, and apply a second coat of dye to make sure it has penetrated the fibres of the fabric. Allow to dry thoroughly.

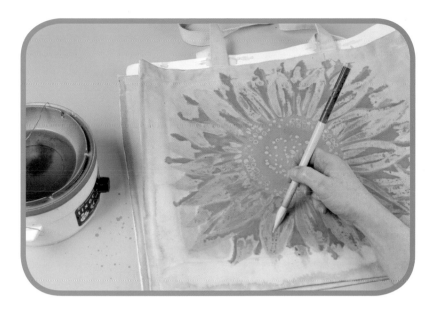

9 Use the round brush to wax all of the petals, leaving a thin gap between each one and its neighbours. When you apply the darker dye later, it will dye these gaps and form the outlines of the petals.

10 Use the pen lid or copper tube as a stamp to add more dots and hoops of wax in the centre.

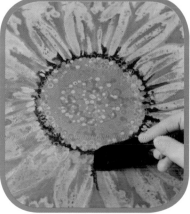

11 Prepare the scarlet dye and use a sponge brush to apply it round the centre.

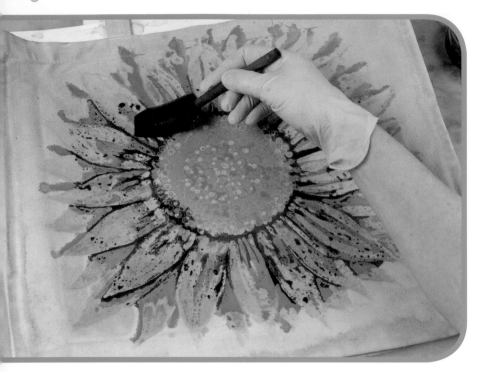

TOP TIP!

If you do not have any red-brown dye, you can make a brown colour by painting over the dye on the sunflower with touches of blue dye. Blue and orange make a brown colour.

12 Make a mix of blue and golden yellow dyes to make a brown dye, and apply touches to the scarlet while it is still wet. This makes a rich brown where the background shows through the mix. The waxed petals will remain the yellow and orangey colour, while the red brown dye will reveal the unwaxed outlines of the petals.

13 Dab the piece lightly with a paper towel to remove any excess dye.

14 Add red and blue dye together to the centre of the flower using a small sponge brush.

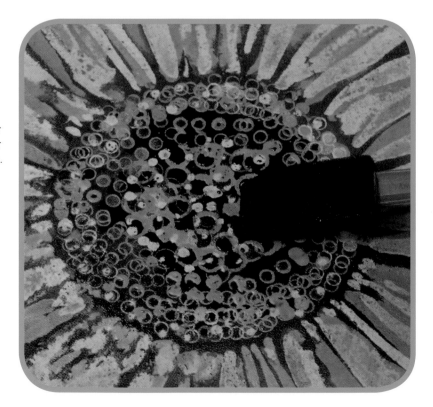

15 Mix blue and lemon yellow dyes together to make a green, and paint it round the outside of the flower.

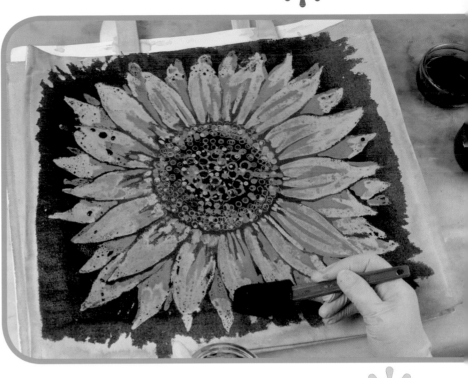

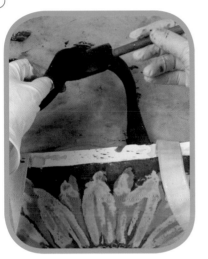

16 Paint the rear handle with scarlet and allow to dry.

TOP TIP!

You can take the bag to the dry cleaners to remove any remnants of wax. However, a little wax left in the fibres helps to make the bag more waterproof, so you may wish to leave a small amount of wax in the bag.

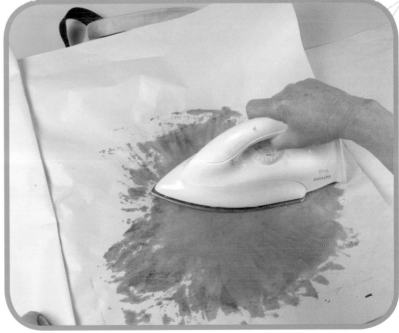

17 Sandwich the bag in newsprint and iron on a medium heat to remove the wax. Repeat until there are hardly any wax marks on the paper.

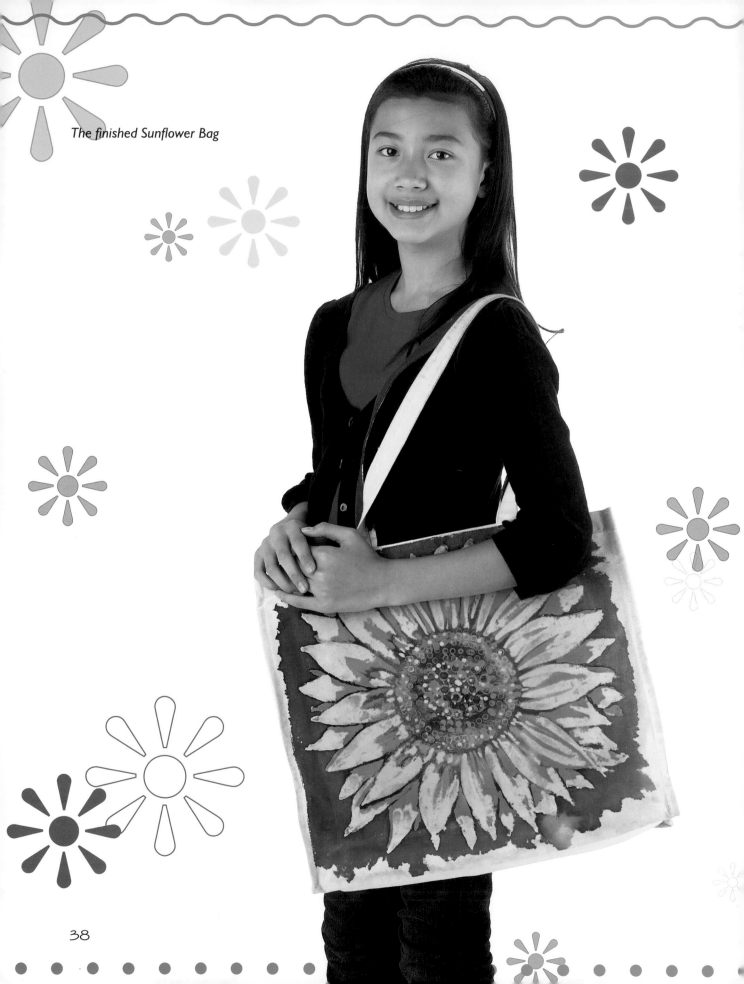

The finished Sunflower Bag

38

What next?

You can brighten up your wardrobe by batiking clothing such as hats, t-shirts, wraparound skirts... in fact, anything made from cotton, silk or rayon can be batiked and dyed!

Dotty Book Cover

You will need

A plain hardback book, (preferably light coloured)

Plain white tissue paper or thin watercolour paper

Wax and wax pot

Kystka

Pointed round wax brush

Scarlet, magenta, lemon yellow, golden yellow, turquoise and royal blue dyes.

Small dye brush

Glass dish

Small scissors

Spray glue

Scrap paper

In this project you will make a cover for a book. By waxing and decorating paper it is easy to transform a book and turn it into something personal and unique. You can also use batiked paper to cover picture frames or to make cards. In this project I have used some spotty tissue paper that was used to wrap up some clothing. You may not be able to find similar paper, so just make your own circles and dots with the wax and dyes. You can write words, draw pictures or experiment with line and colour. Tissue paper is stronger and more versatile than you think and the colours glow when applied to a white background.

STAY SAFE

Always have an adult with you when working with hot wax.

1 Put the book on the tissue paper and cut round it, leaving 5cm (2in) or so around each edge as shown. Fold the paper over the cover to make sure it fits. Close the book to ensure you allow enough paper for the binding.

2 Put the tissue paper face-up on top of some scrap paper. Use a kystka to apply the wax in rough circles around some of the dots, and to add some small dots. These areas will remain white on the finished book.

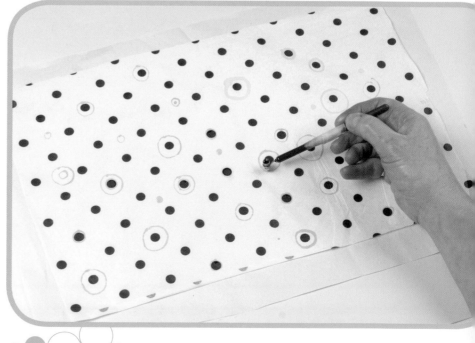

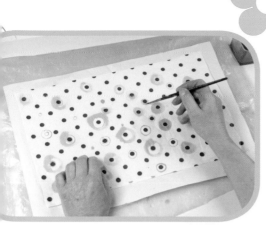

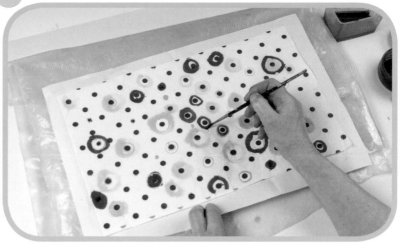

3 Prepare scarlet, magenta, lemon yellow, golden yellow, turquoise and royal blue dyes. Use the small brush to paint hoops in lemon yellow around some of the dots.

4 Allow the yellow to dry, then apply scarlet dye in the same way. Leave this to dry as well.

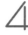

5 Repeat with the magenta dye and then the two blues, leaving each colour to dry in turn.

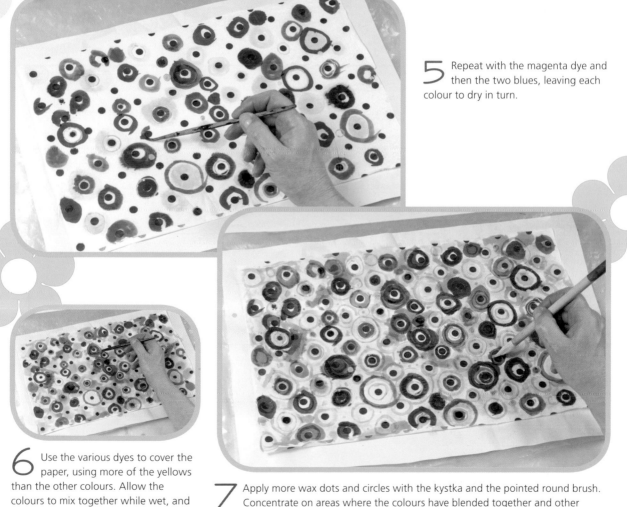

6 Use the various dyes to cover the paper, using more of the yellows than the other colours. Allow the colours to mix together while wet, and leave to dry completely.

7 Apply more wax dots and circles with the kystka and the pointed round brush. Concentrate on areas where the colours have blended together and other places you think look interesting.

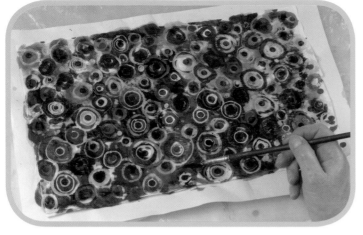

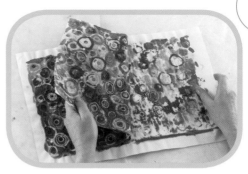

8 Dilute the various dyes with clean water, and use them over the paper in loose patches to cover any holes and to vary the colours.

9 Allow the piece to dry, and then carefully peel off the paper. Be very gentle, as the wax may have stuck to the scrap paper.

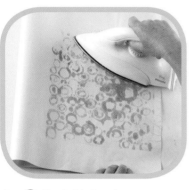

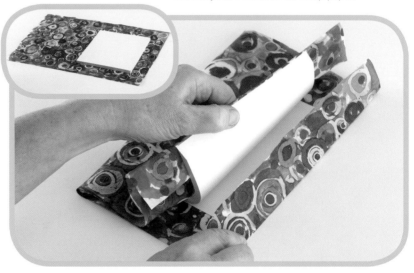

10 Sandwich the piece between newsprint or scrap paper and iron on a low heat until the wax lifts out. Repeat with clean newsprint if necessary.

11 Now you are ready to cover the book. Lay the paper down on the table and place the book on top (see inset), then fold the paper over the front. Fold the edges over on to the insides of the covers as shown.

12 Pick up the book and cut the excess paper on both sides of the spine as shown. Repeat on the other side.

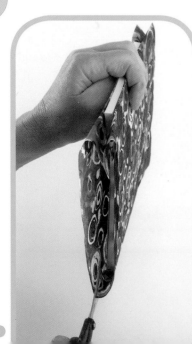

13 Keeping the book closed, cut into the sides at an angle on both sides as shown.

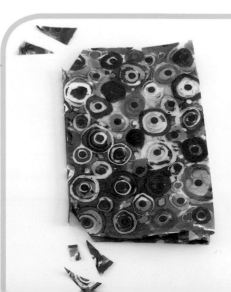

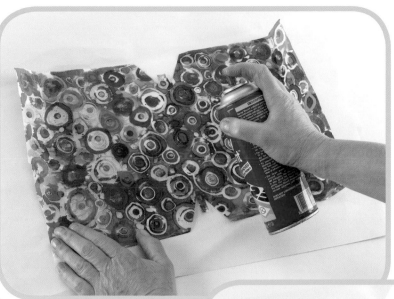

14 Lay some scrap paper down to protect your work surface. Take the book out of the paper and lay the paper flat and face-down. Spray the inside of the book cover with spray glue.

15 Put the book in place on top of the paper and fold the side flaps in, using the creases to guide you.

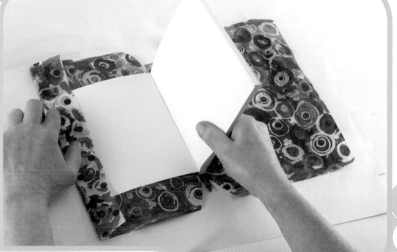

16 Repeat on the other side, and close the book to make sure the fit is not too tight.

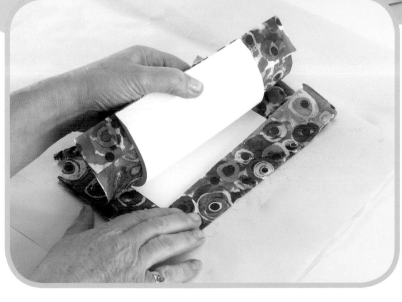

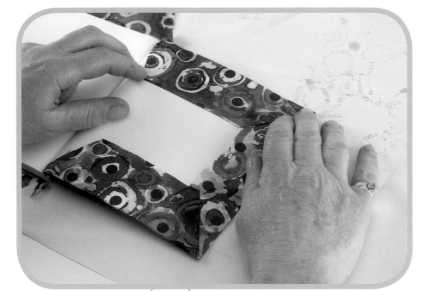

17 Open the book back out. Fold the corners in, then fold the top and bottom flaps in on top. You may need to use a little extra spray glue.

18 Repeat on the other side, then allow to dry to finish (see inset).

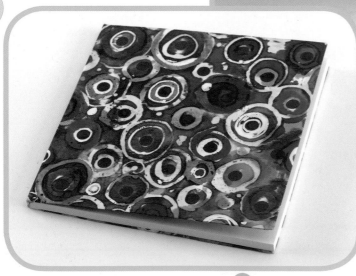

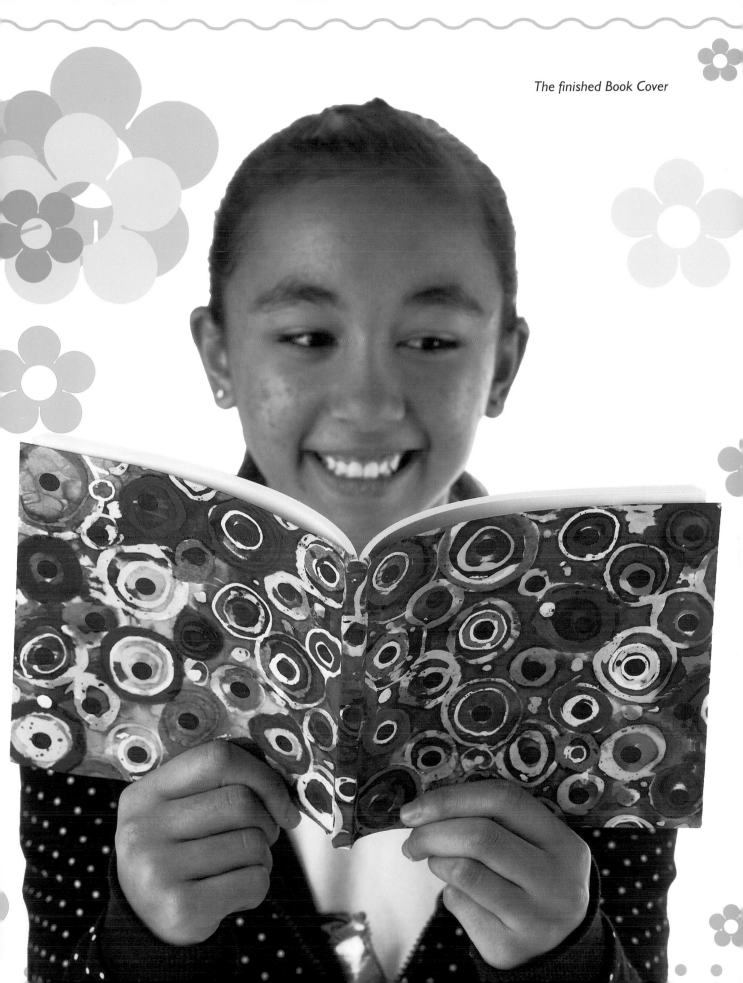

The finished Book Cover

What next?

You can make cards, wrapping paper, picture frames and cover boxes with batiked or wax-resisted paper. When you iron the paper between newsprint, you will find that you will not get all the wax out, as some of it remains in the paper. However you will see that the colours will be richer and the wax in the paper will make it stronger.

It is amazing how hardy tissue paper can be when it is dry. However, when it is wet, it is very fragile and will tear. Always carry it on a dry sheet of newspaper or plastic when applying dyes.

TOP TIP!

You will find that when you wax tissue paper it might stick to the paper or surface below, but this is nothing to be worried about. Do not try to peel it off in case it tears. Wait until you have finished applying the wax and dyes, then allow the paper to dry and iron the wax out between newsprint. You will find the tissue paper separates easily from the surface below.

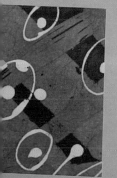

More books to read

Introduction to Batik by Heather Griffin, Search Press, February 1998

Creative Batik by Rosi Robinson, Search Press, January 2001

Useful websites

www.batikguild.org.uk; www.committedtocloth.com; www.kemtex.co.uk; www.rosirobinson.com; www.fibrecrafts.com; www.rainbowsilks.com; www.artvango.co.uk

Glossary

This list helps you to understand some of the more unusual words in this book.

Dip-dyeing Immersion of cloth into a dye bath.

Dry cleaning Cleaning fabric by treating with an organic solvent.

Fibre-reactive dyes Cold water dye which reacts to an alkaline solution to form a bond between the dye molecule and the fibre. It is intermixable, reliable, fast and simple to use on cotton, linen, viscose and silk.

Fixing The process of making the colour permanent.

Microcrystalline wax Synthetic substance derived from petroleum. It is used as a substitute for beeswax.

Paraffin wax Soft translucent wax derived from petroleum. It is brittle and less resistant than microcrystalline wax. Marbling/crackle effects are created by using a greater percentage of paraffin in the recipe.

Resist A substance such as wax, that prevents dye from penetrating specific areas of fabric or paper where the resist has been applied.

Sgraffito Etching a design in the waxed fabric using a pointed tool.

Soda ash A mild alkali, also known as sodium carbonate. This is a form of washing soda that causes Procion MX dyes (like those used in this book) to react in the fibre.

Tulis The hand-drawn batik method.

Index

Aboriginal art 24, 30

bag 4, 8, 32, 33, 38
book cover 40, 42, 42, 45

canting 4, 7, 9, 10, 12, 24, 25, 27
cap 7, 12
cookie cutter 7, 16, 19, 24, 27, 28

dip-dyeing 8, 9
dry cleaning 20, 29, 37
dye 4, 8, 9, 10, 13, 14, 16, 19, 20, 24, 26, 28, 29, 33, 34, 35, 36, 37, 40, 41
dye brush 8, 13, 25, 32, 40, 41
dyebath 9, 19, 20

fabric 7, 10, 11, 13, 24, 25, 26, 27, 28, 29
fix solution 9, 10, 19, 20, 29, 32

iron 9, 14, 20, 22, 28, 29, 37, 42, 47

kystka 7, 9, 10, 12, 24, 25, 26, 40, 41

newsprint 9, 13, 14, 20, 37, 42, 47

picture frames 31, 40, 46

scatter pillow 4, 15, 30, 31
scarf 4, 8, 16, 17, 18, 19, 20, 21, 22
sgrafitto 9, 24, 29

soda ash 9, 10, 16, 19, 24, 32
sponge brush 8, 13, 16, 24, 27, 28, 29, 32, 33, 35
spray bottle 8, 24, 28
spray glue 9, 40, 43, 44
stamping 7, 10, 11, 16, 19, 25, 27, 34, 35
stencil 24, 26, 28

wax 4, 5, 6, 8, 9, 10, 11, 12, 14, 16, 17, 18, 19, 24, 28, 32, 34, 35, 37, 40, 41, 42, 47
wax brush 7, 10, 11, 12, 16, 17, 18, 19, 24, 26, 34, 35, 40
wax pot 6, 10, 16, 24, 27, 32, 40